This Notebook belongs to:

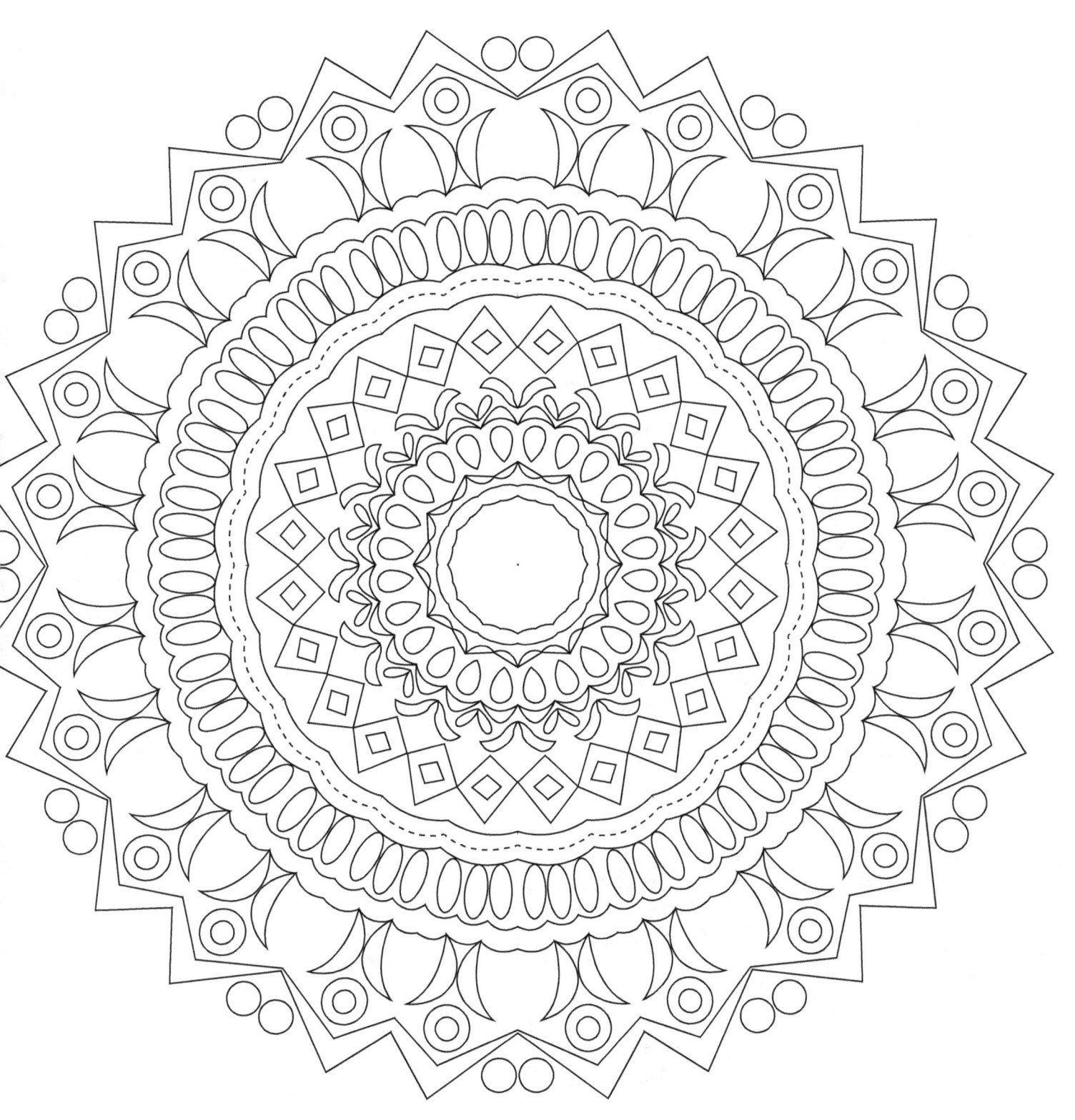

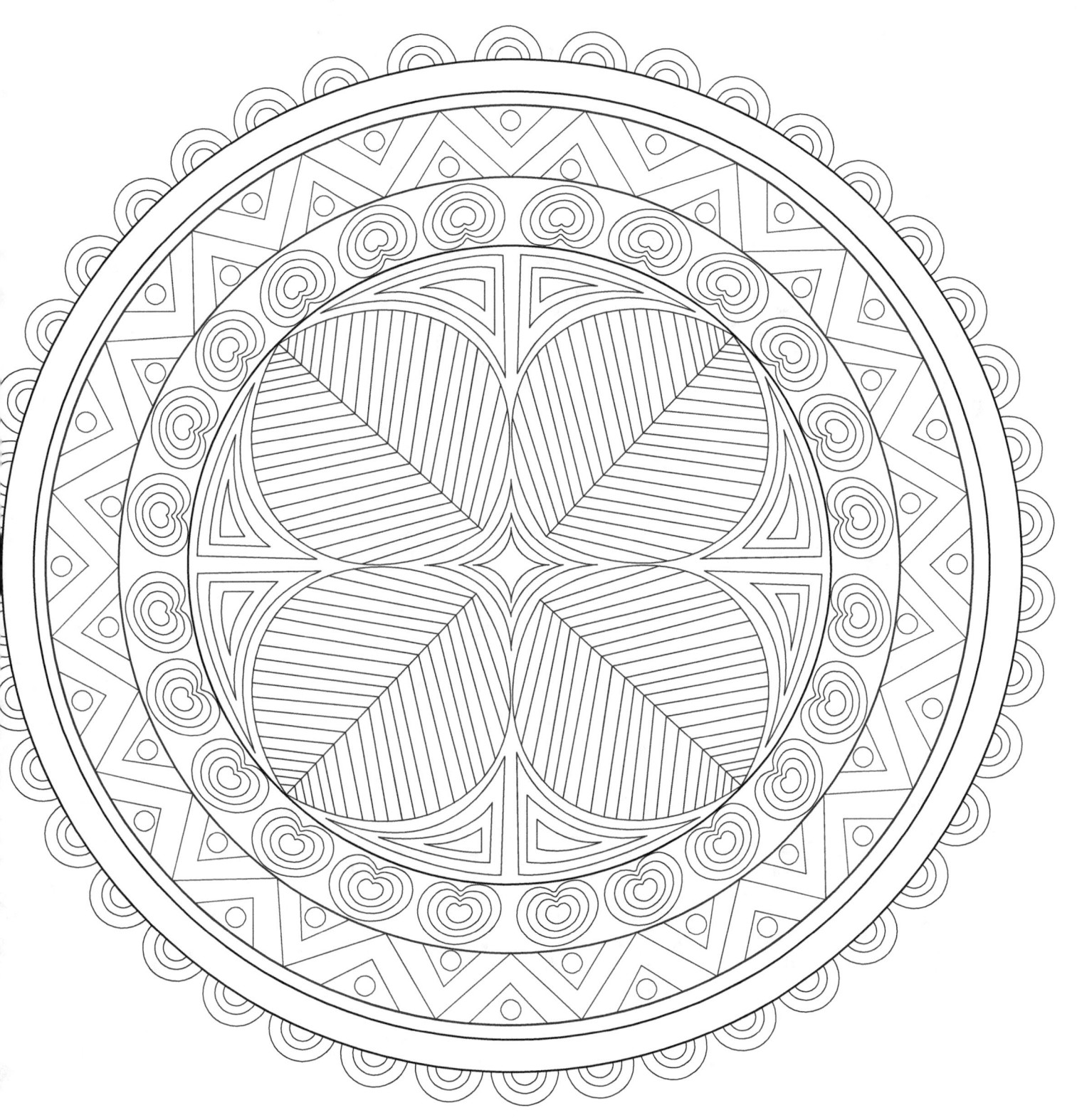

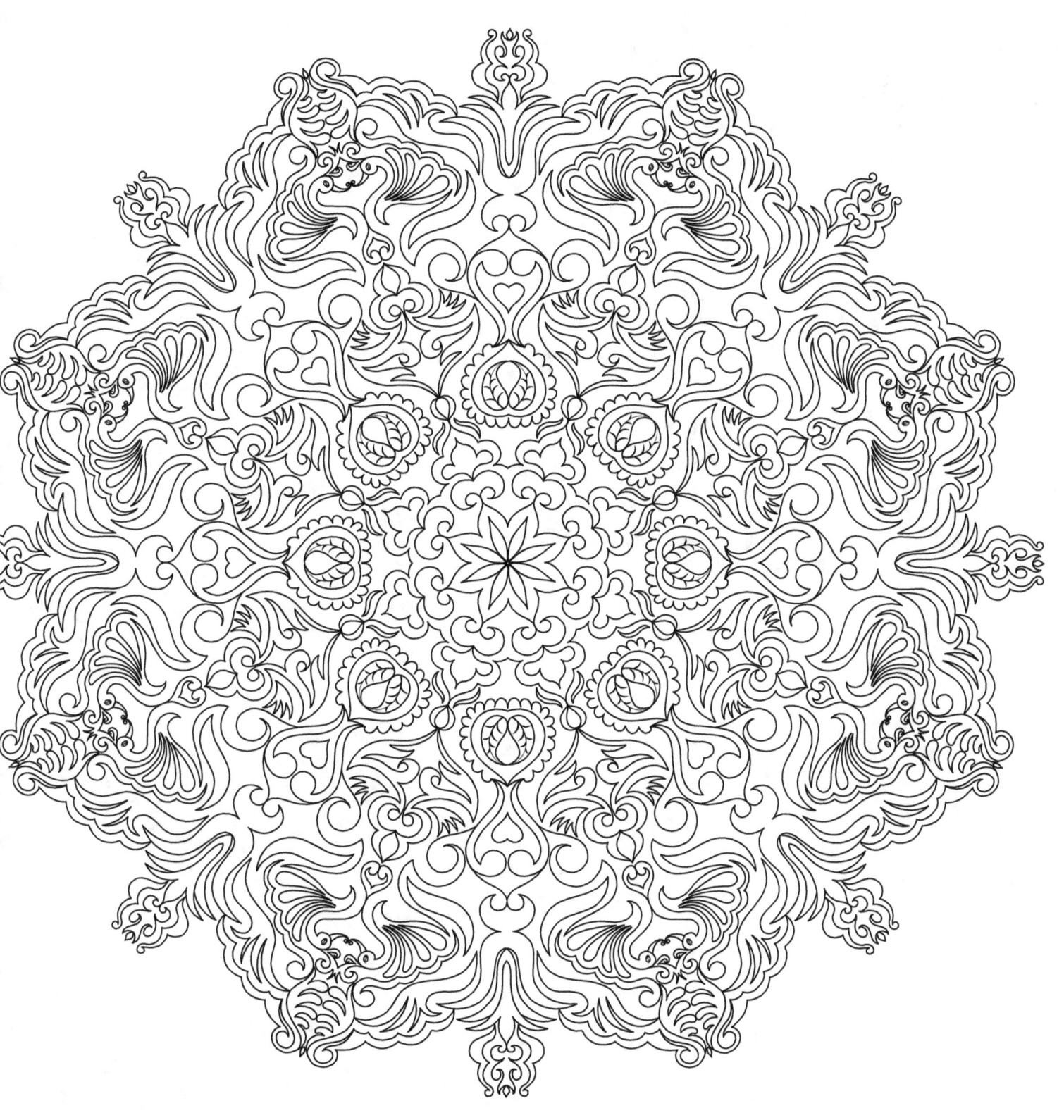

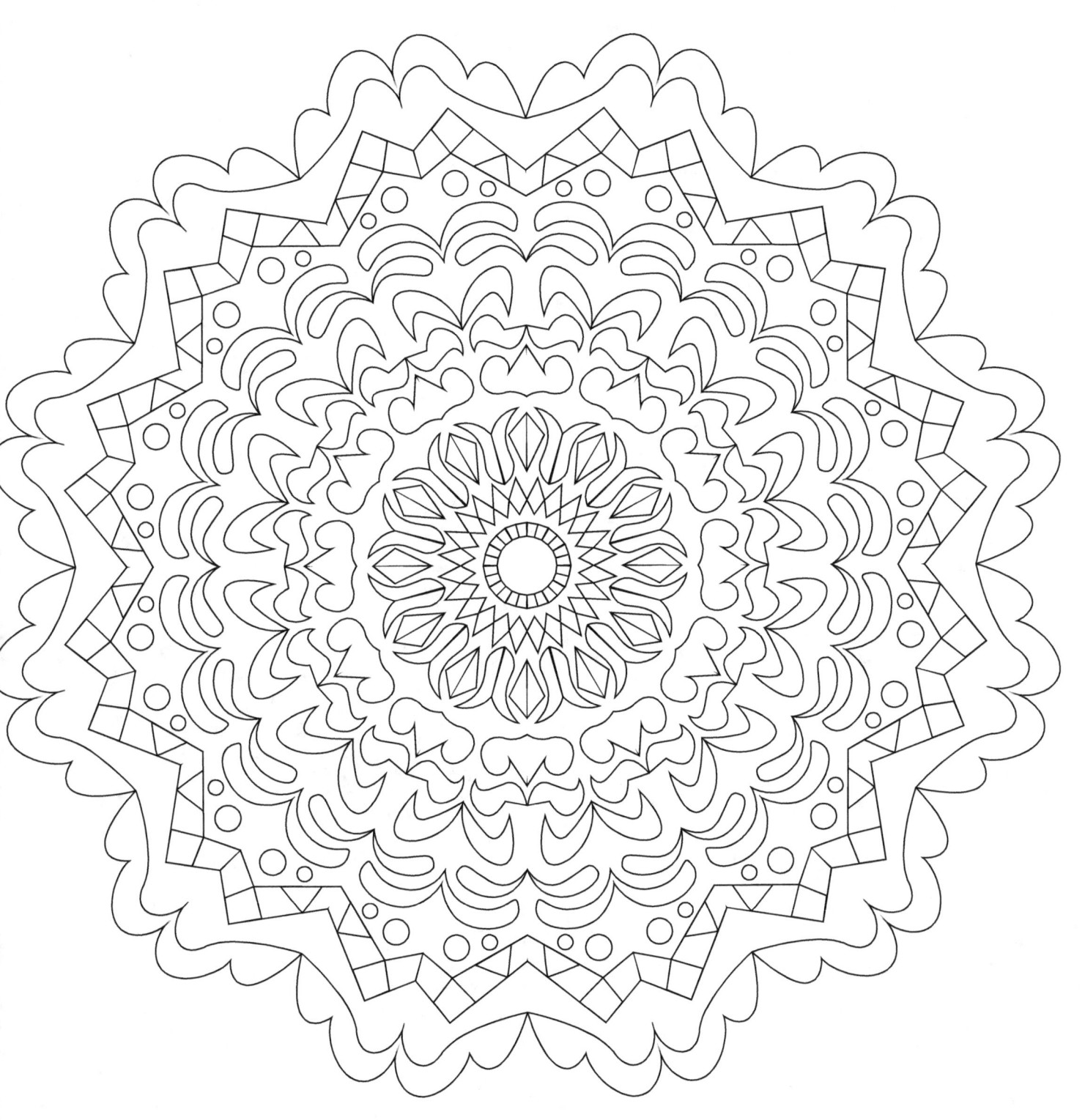

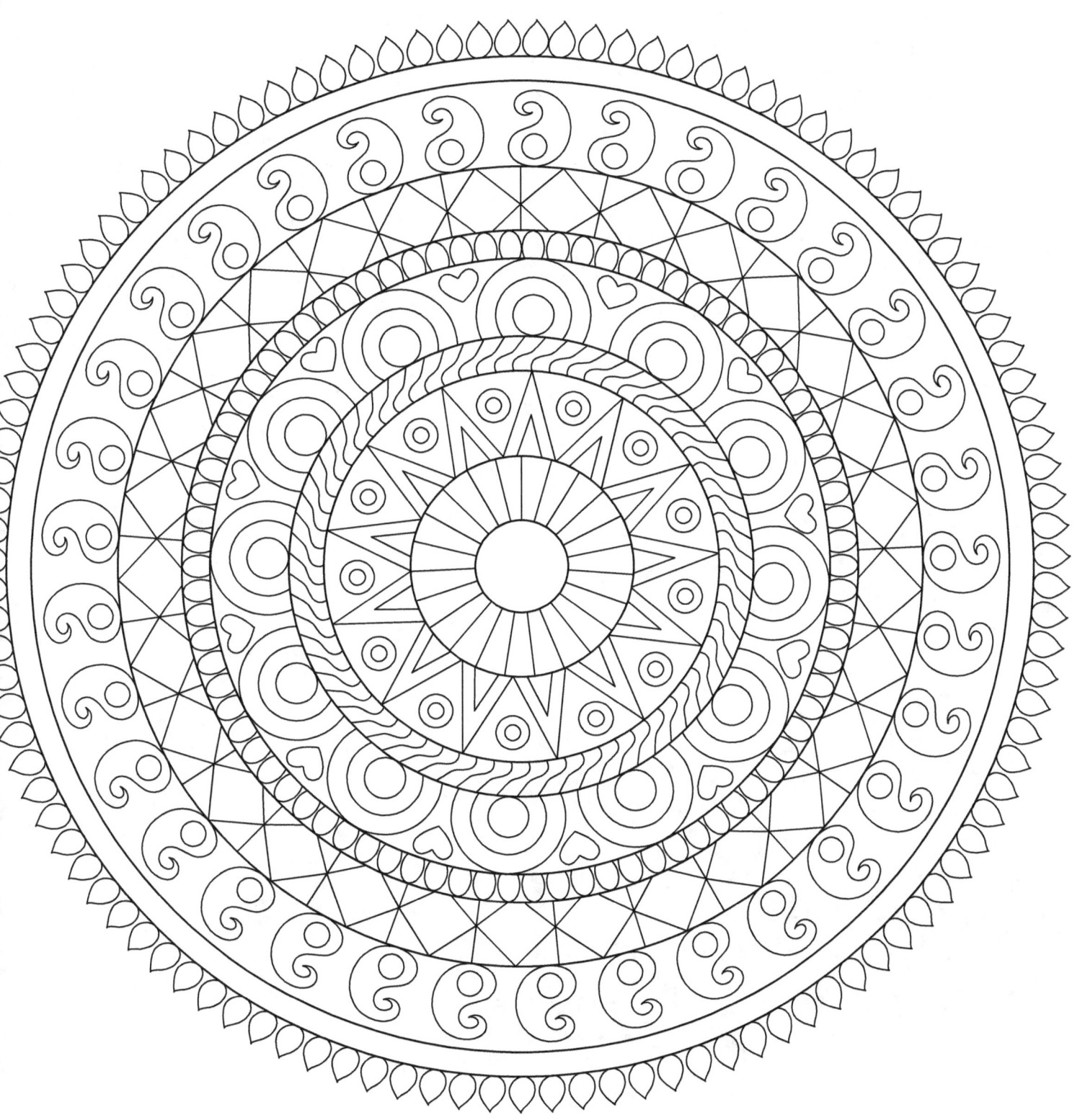

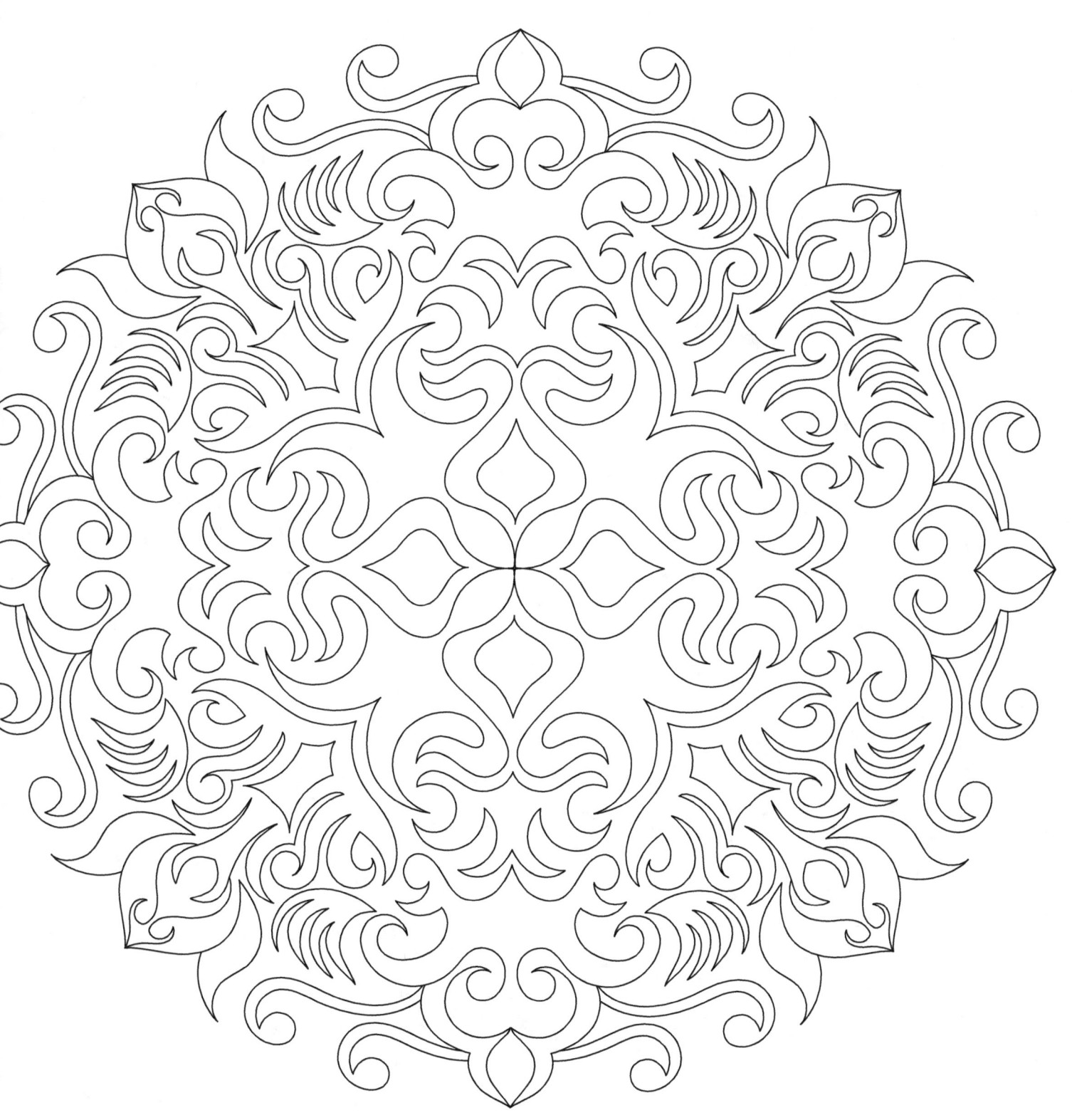

MAZE

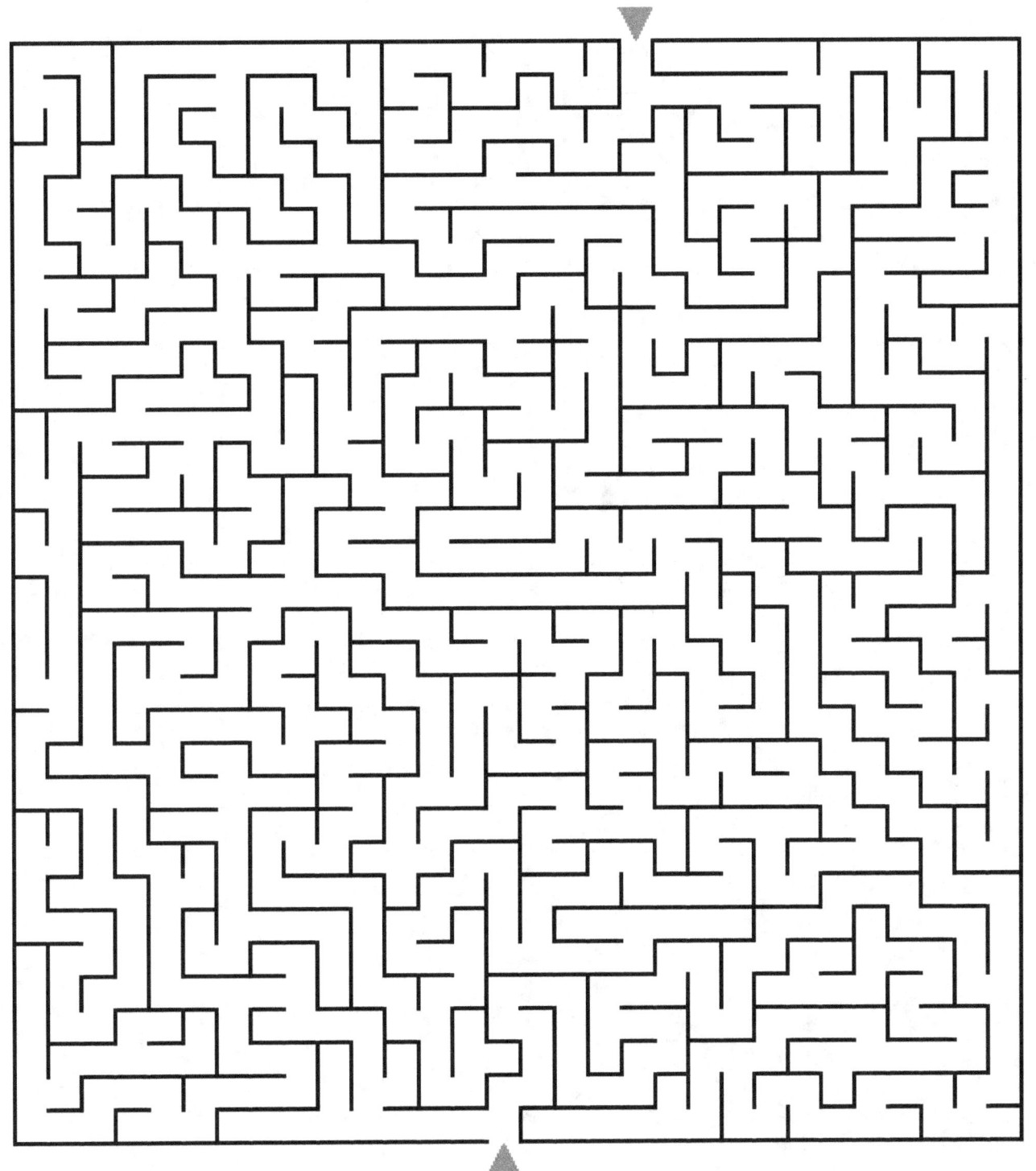

COLOR CHARTS

Solution

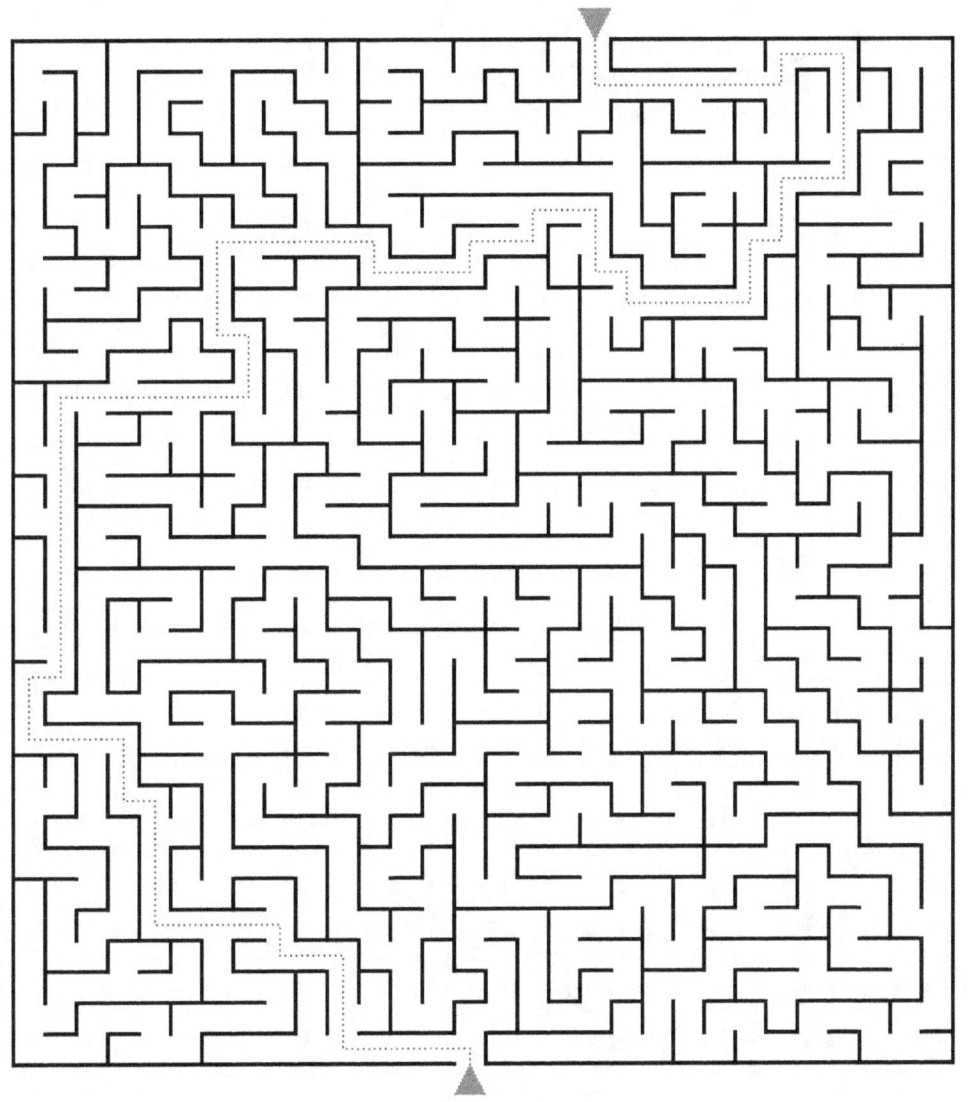